Daylight

T0125269

# I WRITE ARTIST STATEMENTS

LIZ SALES

**15** Y E A R
ANNIVERSARY

Cofounders: Taj Forer and Michael Itkoff
Creative director: Ursula Damm
Copy editor: Elissa Rabellino

ISBN 978-1-942084-52-5

Printed by ARTRON, China

Daylight Books
Email: info@daylightbooks.org
Web: www.daylightbooks.org

*For Steve*

# Introduction

At some point in their career, an artist will more than likely be involved in the process of writing an artist statement. They will often think this creation to be a simple task until they actually have to do it. The art of describing themselves and their work is not an easy feat. They will panic. They will sweat. They will, as Gene Fowler says, "sit staring at a blank sheet of paper until drops of blood form on [their] forehead."

Everyone should try to write about their creative work. Writing is just an organized form of thinking, and thinking about your work helps you to make better work. However, many artist statements end up vague, lyrically romantic, verbose, obviously trying to impress with unnecessary vocabulary. Pompous things to avoid include too many quotations from philosophers, writers, or artists and too much technical talk. The point of an artist's statement is not to provide the audience with a complete education or to highlight in jargon all the complicated aspects of a manual that most folks cannot comprehend. Its challenge is to distill and clarify an artist's intention in an accessible way through language. Who are you? What did you make? How did you make it? And why is that important to you? People are interested in other people, and their narratives and the statements should be welcoming.

Liz Sales is an artist, and also a go-to person to help navigate this system. She has provided assistance to countless other artists who feel that making work and being able to write concisely and articulately about it are two entirely different skill sets. In this little paperback, Liz uses her understanding of the structure of the artist statement to construct statements for fictional photo-based artists that satirize art school, gallery, and popular photography clichés, as well as describe impossible projects that simply could not exist off the printed page.

—Matthew Carson, head librarian and archivist, International Center of Photography

*Things that don't quite make sense
can be most valuable tools.*

—David Wilson, director, Museum of Jurassic Technology

*Truth may be stranger than fiction,
goes the old saw, but it is never as strange as lies.
(Or, for that matter, as true.)*

—John Hodgman, *The Areas of My Expertise* (2005)

*Beginning a written work with a
succession of semi-obscure quotes
is often a sign of insecurity.*

—Anonymous

## The Mad Libs Statement

I am an artist who works with _____. Ever since I was _____,
                            (medium or material)                (number)
I have been interested in subverting the traditional understanding of

_____. My work explores the relationship between _____
   (noun)                                                    (art movement)
sensibilities and _____ spaces. With influences as diverse as
                     (adjective)

_____ and _____, my work is both _____ and
  (proper noun)        (proper noun)                    (adjective)

_____. As a result, the viewer is left with a testament
(antonym of the previous adjective)

to the _____ _____ of the human condition.
        (adjective)   (noun)

## Martin Shear

Martin Shear is a self-taught artist who works as a custodian at an elementary school in Nashville, Tennessee, by day and paints, from photographs, on small, pre-stretched canvas in acrylic by night. His family's home is filled with dozens and dozens of paintings that measure 8 x 10 inches, as well as a handful of even smaller ones placed on shelves. Some of these paintings are made from postcards depicting the Nashville skyline, because the skyline is pretty and familiar, while other paintings depict his wife's guitars because he likes painting guitars and Betsy owns quite a few.

Like other artists who have chosen to live far from the Chelsea galleries, he regularly posts his paintings on Facebook and Instagram. His paintings are just the right scale for documenting with his Samsung Galaxy 6 and posting on social media sites. Friends and strangers see and like his work: they give him encouragement and, sometimes, they reach out to him about purchasing a piece. Essentially, Shear is happier than you are. You're way too fucking precious about your work.

## Untitled Artist Statement

These stunning images of sidewalk litter shot in nature highlight our undeniable impact on the environment, including the urban environment. My interest in repurposing trash in the service of art began on the day I volunteered to chaperone my son's Cub Scouts troop on their community service day, collecting litter. While the boys removed the refuse from the sidewalk, placing it in trash and recycling receptacles, I watched, struck by the beauty of a crushed Fanta can backlit in the gold tones of the early morning light.

I began transforming garbage into art. I shot cigarette butts, straws, latex balloons, Styrofoam cups, used condoms, and an old set of flip-flops, leaving each where I found it. These images bring attention to the environmental issue of trash, beautifully rendered trash. All the items imaged began as useful objects, but as a result of human behavior, negligence, or forgetfulness, they ended up on the street. I transform this trash into art with an important message: I am a special person who sees beauty everywhere.

Fans of my street photography often ask me, "Is that real, or did you use Photoshop?" I do not "mess with nature." I create art. I am a photographer who posts final images straight from my camera to Flack Photo's Facebook page. These images are true in the truest sense and fully express who I am and what I see in the most literal sense. When I take a picture of a seagull soaring over Bay Harbor, I am not speaking about elevated consciousness or self-confidence or whatever else you've written in my comments section; I am taking a great picture of a bird, by panning my camera along in time with this moving subject so that the bird is a relatively sharp subject but the background is blurred. Panning is a technique that can produce amazing results if you perfect it, which I have.

Some say the term "photographer" fails to accurately describe the vast majority of artists working with cameras. These people are wrong. A real photographer is able to perfectly capture the scene in front of him and share it with his online community. If he is honest and open, he will also share his ISO, aperture, and shutter speed. This technical information is the artist's real artist statement. "Artist statements" as the liberal elite are taught to write them, in their nurseries of "higher learning," add nothing to the photographic image, which should speak for itself.

May the light be with you!

## Gustav M. Christoffersen

Gustav M. Christoffersen (b. 1992, Oakland) is a space artist who creates photo-based pulp sculptures as an architectural stage for his social practice, which is concerned with the narrative of cyclical realities. Christoffersen urges us to renegotiate physical realities as being part of oppressing themes in our post-contemporary, image-based society. By choosing formal non-solutions, he creates hyper-personal moments born by means of omissions, refusal, and Elmer's glue. He invites the viewer round and round in circles of photographic sculptural matter. He manipulates these structures in order to deconstruct socially defined spaces and their uses and post-possibilities.

Multilayered conceptualism arises in which the fragility and instability of our seemingly real reality is queried. The results are deconstructed so that meaning is soaked in possible interpretations of impossibility. With an under-conceptual approach, he creates with daily, recognizable photographic imagery an unprecedented situation in which the viewer is shown the conditioning of his or her own image space and has to reconsider their own life.

The artist's forms do not follow logical criteria but are constructed through subjective associations and formal realities, which incite the viewer to make new personal associations by rejecting and re-rejecting seemingly objective narratives. His works directly respond to the surrounding environment and frame instances that would go unnoticed outside of his constructed context. By applying anti-abstraction techniques, he tries to approach a broad range of subjects in a multilayered way, likes to involve the viewer in a way that is sometimes physical, and believes in the idea of function following form in an anti-work.

## Indycay Ermanshay

Indycay Ermanshay established name recognition with a once-innovative brand of self-portraiture. Her series *Untitled Movie Posters* (1979) pictured the artist herself in re-creations of 1940s and 1950s film noir movie posters. Always in meticulous costumes, wigs, and makeup, she enacted female clichés from film posters of stylish Hollywood crime dramas for the camera. These works reexamine women's roles in history and contemporary society.

*Pinup Girl* (1998) is a series of photographs of the artist herself enacting female clichés present in 1960s pinup posters. Always in meticulous costumes, wigs and makeup, she enacted female clichés from pinup-girl posters of the 1960s. These works continually reexamine women's roles in history and contemporary society.

*Dutch Mistresses* (1988) is a series of photographs of the artist herself enacting female roles from the Dutch Golden Age of painting. Always in meticulous costumes, wigs, and makeup, she enacted female clichés from 17th-century Europe. These works continually reexamine women's roles in history and contemporary society over and over and over and over and fucking over again.

*Customer* (2008) is a series of photographs of the artist herself dressed up like wealthy art collectors. Always in meticulous costumes, wigs, and makeup, she produced a series in which she dresses like the women who champion and patronize her work. These works give credence to the adage "If it ain't broke, don't fix it."

## Vlad the Impaler

Vlad the Impaler (b. 1431, Sighişoara, Transylvania) is an artist who mainly works with photography. By employing flat formal solutions, his photography has a distinct lack of visual drama in a way that echoes his undead soul. In turn, the image approaches an objective gaze where the subject, rather than the photographer's perspective on it, is paramount.

The Impaler's images are flattened out, formally and dramatically, in the manner of the typologies and straight photography espoused by his teachers, Bernd and Hilla Becher. The Impaler's best-known project is *Mina*, a series of 60 frontal, identically framed photographs of Wilhelmina Harker, the reincarnation of the artist's centuries-dead wife, Elisabeta, staring deadpan into the camera. As a lifeless monster, he does not believe in psychological portrait photography the way his colleagues do. He is not trying to capture the character of his subject. He believes he can only show the surface; everything beyond that is up to the viewer.

Due to his interest in reincarnation, authenticity and appropriation are of recurring interest to the Impaler. He further explored these ideas in *Bran Castle*, a photographic collection of portraits of the artist's childhood home and other Transylvanian castles, all taken from the same angle with the light evenly distributed, and printed in identical size. The intense and obsessive nature of the Impaler's project mirrors the soulless order of industrial production, a phenomenon that greatly altered the 500-year-old vampire's world and worldview. Vlad the Impaler currently lives and works in Tampa, Florida.

## Biography: Jason Blank,
## America's Most Prolific Postcard Photographer

Jason Blank's postcards celebrate the wonder and invention of the landscape, drawing on everything from early pictorial photography to German Romantic painting. From local post offices to tourist information centers to airport newspaper kiosks, Blank's grand-guignolesque sensibility deepens our complex relationship to nature. Despite a dwindling need for postcards, Blank continues to shoot San Francisco, Boston, New Orleans, New York, Chicago, Montreal, and Vancouver over and over again, with a passion both terrifying and sublime. He also has an obsessive interest in folk culture, and his predilection for "the exotic" seamlessly combines the racist traditions of early photography, Romanticism, and postcard photography. Blank, of course, also considers himself a supremely individual creator and uses a drone to shoot landmarks from a high viewpoint and transcendent common experience to reach deeper spiritual truths or something.

## Claire Fisher

I first learned that I was an artist from my Aunt Sarah. She'd seen a collage I'd made for a school assignment, a self-portrait casting myself as Medusa, and proclaimed me "a natural." Later I found photography through my brother-in-law Billy, who invited me over to take pictures of him. I captured the curve of his spine of his back, and through this gesture somehow revealed his vulnerable character while foreshadowing our future together.

While studying art at LAC-Arts College, I focused primarily on my family and home life. I was born and raised above the funeral parlor that my late father and brothers owned and operated, so my daily life was rich with content. For example, a plumbing issue once caused blood to erupt in our house, and I was able to capture the aftermath, visualizing the strange nature of our lives and relationship to death.

As a college student, I, of course, briefly experimented with lesbianism, with my friend Edie. While this relationship was short-lived, it did bring me back to portraiture. This led me to my biggest artistic breakthrough, portraits achieved by shooting and printing images of individual subjects, ripping those prints up and then reassembling them into masks to be worn by the original subject. The resulting images combine photography, collage, and sculpture while referring to the concept of the death mask.

While I am unclear on what work I made, after moving to New York, I'm glad to here that I will marry my ex-boyfriend Ted, after returning to California in 2025, and even happier to know that I will die of old age, surrounded by friends and loved ones, to the tune of Sia's "Breathe Me."

**A few questions to ask yourself while viewing my video art:**

1. Does it matter that I didn't start watching this at the beginning?

2. Why do I have to wear headphones to hear the audio?

3. Why is it so cold in here?

4. Why are all the lights on?

5. Why is this bench so uncomfortable?

6. How much more is there?

7. How will I know when it's over?

8. Is it appropriate for me to just stop watching now?

9. Why can't they just show this in a theater?

10. Why can't they just show this at Alamo Drafthouse, so I can order beer and fries?

## Oliver Curry

Oliver Curry is one of the most respected photographers working today. He forged his reputation as a photojournalist through decades of powerful black-and-white images of social and ecological disaster. Whether he's documenting refugees or vast barren landscapes, he knows exactly how to grab the essence of a moment so that when one sees his images, one is involuntarily drawn into them. These highly resolved and beautifully rendered photographs depict the effects of war, drought, and famine in developing nations from a comfortably safe distance. They successfully purport to teach us the disastrous effects of war, poverty, and disease, without implicating us or suggesting a call to action. From the Lost Boys of Sudan to displaced Syrian refugees in government-run camps in Turkey, Curry has turned suffering people into beautiful objects of easy consumption. In doing so, he has challenged our perception of documentary-led photographic conventions as useful or relevant.

As the availability of editorial photography jobs for magazines and newspapers has waned, Curry has turned to the gallery as a showplace for such documentation of post-tragedy life. Contemporary art photography now presents a market for the consequences of political and human upheaval. This is because under Curry's skillful gaze, the camera has the power to turn human suffering into collectible objects that art enthusiasts would like to buy and own. Relocating his work to a smaller audience was not only a financial decision for Curry but also an ethical one, because "concerned photography" has done at least as much to deaden our conscience as to arouse it. The more photographs of suffering we see, the less shocked we are. Curry's counter-photojournalistic aftermath photography now reaches a discreet audience, where it can do the least amount of damage for the highest monetary return.

## The Seattle Camera Club for High Modern Real Estate Photography

Photography has never been more important to selling real estate than it is today. The markets are heating up again, and demand for real estate creates demand for photography. Highlight your listing during a 12-hour session with one of New York's finest high modernist architectural photographers! We here at CCHMREP believe the camera artist should find, not invent, his subjects, so additional lighting will not be used to enhance your listings. Buyers should see your home as it truly is. There is no need to even tidy your home before we arrive. In documenting your space, your photographer will attempt to render things as objectively as he finds them, true to European modernist form.

The creative achievement of our camera artists lies in their perfect photographic depiction. All our photographers shoot black-and-white, large-format film, with no affectations or painterly photographic effects. Your artist will select the perfect camera view, focal length, and exposure time for your listing.

All our real estate images are printed in the wet darkroom. And at CCHMREP, no manipulation of the exposed negative is permitted in the darkroom. Our photographs are of the highest technical prowess, and their prints contain a rich range of tones, without manipulation. You will love your handmade 16" x 20" fiber prints. If you need to put these images on the Internet, you have the option of scanning and posting them online. However, if you choose this contemporary modality, please refrain from accompanying our images with any text. Images should speak for themselves.

## The Portland Collective for Post-Modern Real Estate Photography

Photography has never been more important to selling real estate than it is today. The markets are heating up again, and demand for real estate creates demand for photography. We at the Portland Collective for Post-Modern Real Estate Photography believe the photo artist must invent his subject. Please be advised that, once hired, we may shoot images of your home, another home, or another subject altogether. This is entirely at the discretion of your assigned member of the collective.

Your photographer may use found images produced by other photographers. This means your listing may only include vernacular images that your photographer discovers at yard sales.

If your assigned collective member chooses to shoot your home, all exposures are acceptable; the choice is a function of the intentions of the individual artist you are assigned. Just as in any post-modern medium, technical finesse is a standard for quality in real estate photography.

Major photographic manipulations of our images are also welcome by the Portland Collective for Post-Modern Real Estate Photography, the more imaginative the better. Want to know what your home would look like if it were filled with composited images of Saddam Hussein? Good, because the creative achievement of the artist associated with the Portland Collective for Post-Modern Real Estate Photography is measured according to his ability to undermine the camera's claim to the idea of "truth."

Any listing of images created by the Portland Collective for Post-Modern Real Estate Photography must be accompanied by a lengthy statement created by the artist who produced them. Concept-based art requires thoughtful text. Please do not muddy such thoughtful text with pricing or location information.

## Untitled Artist Statement

*At the end of the day, what I show is real life. I tell the truth. And the truth can be shocking.* —Larry Clark

*I purposefully try to make films in that gray area, where things are morally ambiguous. It's like life: good people do horrible things, and bad people do good things, and there's beauty in horror and horror in beauty.*
—Harmony Korine

My work resists the mores of the petite bourgeoisie, characterized by the repression of emotion and sexual desire, through the medium of "pornography." I am not happy unless I am working the outer limits of moral acceptability. I bear witness to social truths.

Only a philistine would miss the biting references to conspicuous consumption and suburban sprawl in *Pure XXX—Pizza Guy*, a series of encounters, each featuring an unsuspecting young lady opening a pizza box to discover the delivery man's cock jammed through a hole in the bottom of the box and poking out from the center of the pizza itself.

Similarly, *Hot for Teacher 6*, a short piece aping the style of 1980s educational films, critiques similar cultural mores, most specifically our neo-fascist education system. This piece asks the question: Are these scantily clad girls suffering poor grades due to a one-size-fits-all standardized testing regime that does not really educate students but merely teaches them to pass a test or fellate their instructor to make up the credit?

My work also challenges the traditional value of story, acting, and technical proficiency. *Doing It Dogme Style 1–11* is a series of handheld, single-shot short films featuring cheerleaders who can't shower together without a

lesbian orgy ensuing. This raw and immediate project, shot on location, uses only available light to illuminate the scene and only available objects as "props." It dares the viewer to enjoy a lesbian orgy without the pomp and circumstance of high production value.

My full catalogue raisonné is available through PornHub.com.

**Tila Tequila**
Zine Fest Houston
Lawndale Art Center
4912 Main Street
Houston, TX 77002

**FOR IMMEDIATE RELEASE**

Local artist Thien Thanh Thi Nguyen, better known by her stage name, Tila Tequila, has mined her personal Myspace.com archive for photographs and text, which she published in discrete, one-of-a-kind, handcrafted artist zines that can be unfolded and refolded to create poetic juxtapositions. Each has all the idiosyncratic details of a diary, offering snippets of the artist's dreamy, quixotic, and whimsical musings. The archival images are subtly beautiful, and the way she has combined them with text heightens their impact. Tequila's work will be available at Zine Fest Houston, an event dedicated to promoting zines, mini-comics, and other forms of small press, alternative, and underground DIY media and art, where Tequila will be sharing a table with Berlin-based artist Joachim Schmid.

### Down and Out in the Bible Belt

*Down and Out in the Bible Belt* is a photographic project containing 35 portraits of homeless men and women in cities throughout the American South, as shot from the window of my car. For these portraits, I came up with an original approach: to photograph homeless people from the comfort and safety of my vehicle.

My approach necessitated photographing these people in dramatic black-and-white against urban backdrops, framing in the graffiti and empty bottles that complete each picture as quickly as I could. This meant scouting the most picturesquely homeless people I could find in South Carolina, Georgia, and Mississippi, particularly those with beards and hats, and making sure to include their typical paraphernalia, such as shopping carts and sleeping bags. In essence, I am showing the viewer who these people truly are, as seen from a speeding 2008 Jeep Cherokee.

**Doug the Quotidian!**

We all remember the unflinching work of Weegee, who is best known for his stark black-and-white street photographs depicting crime, violence, and death on Manhattan's Lower East Side, in the1930s and '40s. This brilliant artist, who operated under the moniker Weegee the Famous! influenced the likes of Jack Donohue and Stanley Kubrick.

He has also had a profound influence on me, Doug the Quotidian! My life's work has been documenting small crimes and misdemeanors in Springfield, Indiana. I use a police scanner to track inconsequential crimes such as damaging mailboxes, picking flowers on private property, violating a public park curfew. Then I drive to the scene to capture the aftermath— more often than not, an empty parking lot.

## Mars Rover Pair Spirit and Opportunity

Rover pair Spirit (January 4, 2004–March 22, 2010) and Opportunity (b. January 25, 2004) were two robots that landed on opposite sides of Mars in 2004 in order to continue the work of master photographer Ansel Adams. Spirit and Opportunity recorded a range of subject matter, from panoramic images that resemble landscapes of the American West to 3-D images that resemble landscapes of the American West. Like Adams, Spirit and Opportunity disliked the term "landscape photographer," because they were technically remote-controlled, data-gathering robots. However, as they have been the only two photographers documenting the red planet from the ground, most critics would agree that, in terms of Martian landscapes, Spirit and Opportunity are in a class by themselves. The National Aeronautics and Space Administration (NASA) represents the late Spirit's estate and the work of Opportunity, who still lives and works on Mars.

**FOR IMMEDIATE RELEASE**

Yale University Press—London
47 Bedford Square
London WC1B 3DP

**New Publication: *On Creating a New Reality***

"I just don't know Donald," a teacher once wrote on the envelope containing one of Trump's report cards. Even today, most people don't "know" President Trump in the sense that he's not an intelligible person you can comfortably wrap your head around.

*On Creating a New Reality* is a new historical monograph published by Yale University Press that presents performance artist Donald Trump's full oeuvre in images and text from the artist's own online archive. Instead of explanatory essays, the edition presents everything from Trump's original birth certificate to actual hate mail he received from women challenging him to wrestle in the Intergender Wrestling World Championship.

However, the focus of the publication is Trump's improvisational piece, *Campaign*, created using only the social media platform Twitter. Selections from this seminal, ongoing, concrete poem, released 140 characters at a time, give the reader a sense of how the artist invaded our political system from the outside to reveal all the chinks in its armor and create his latest work, *President of the United States of America*.

But does this feat make Donald Trump the greatest, most winning, and huge performance artist ever? Performance art remains a largely European discipline, beginning with Joseph Beuys and continuing up through today with Marina Abramović. But neither has made work with the same

real-world, life-and-death consequences as Trump. Americans such as Laurie Anderson, Miranda July, and Sarah Palin have each at one point been referred to by critics as the greatest, most tremendous, and classiest living American performance artist. However, none of them have demonstrated the sheer commitment of Trump, who has managed to affect more people in his short artistic career than most artists manage to do in a lifetime.

**Dear** _____,

I am an avid reader of your blog. I particularly enjoyed your post about _____ because _____. I am sending you a press release of my upcoming show, as based on your work, I think it might be of interest to you.

Normal things need my help to be interesting. I photograph the banality of daily life, attuned to the overlooked, romantic details of mundane objects. Through my lens, bottle caps, cocktail umbrellas, and shirt buttons undergo transubstantiation. And by transubstantiation, I mean macro photography. I use extreme close-up photography to photograph very small subjects and then print finished photographs of these subjects at a much, much greater size. Picture a burnt-out light bulb. Interesting? No. Now look at my 72 x 48 inch digital C-print _Burnt-Out Light Bulb_. Better, right?

See, the ratio of the subject size on the film plane to the actual subject size is known as the reproduction ratio. My reproduction ratios are much greater than 1:1, making for much more interesting images. For example, lately I've been producing large-scale mural prints of images of my toenail clippings. As with all of my work, there is also a lugubrious sense of loss that connects my subject with my medium: like toenail clippings, photographs are objects ripped from their original context, serving as a _memento mori_. This is most evident in a very large photograph.

Best wishes,
Janele Pacey

_For more information, please Google me._

## Scraps of Life

My work is diaristic and concerns human intimacy. I shoot in a casual and amateur style resembling snapshots. These shots feature my intimate family relationships as well as my social life. I print these images at my local Walgreens. The harsh color photographs they produce, coupled with my candid style, demand that the viewer go beyond the surface to encounter a profound intensity, triggering real memories of smells, sounds, and physical presences.

After all my prints are made, I generally separate the photos by event and stack them chronologically. These stacks are divided by theme, like the trip we took to Tampa, Florida, with the kids in June. Once I have them all organized into piles, I start adding them to my 6 x 12 scrapbook chronologically. I leave lots of space for journaling cards and bits of ephemera—business cards, ticket stubs, etc. I tuck those little things into pockets in the album so that I know what I'm working with when I return to those pages to work on them. So when I go to scrapbook these layouts, they'll be ready to be scrapbooked—no fuss printing photos or digging out the little bits I've saved. I'm ready to make art!

In the end, my scrapbooks are a visual diary chronicling the struggle for intimacy and understanding between friends, family, and lovers. My work describes a world that is visceral, charged, and seething with life. By creating an accurate and detailed record of my life, like my sister Racheal's wedding in Passaic last September (boy, was that a scream!), my scrapbooks reveal my personal odyssey as well as a more universal understanding of the human condition.

## *Vine Girl: Intimate Encounters with Creeping Plants*

A love of Nature is embedded in the human psyche, and nothing is more emblematic of Nature than the vine. Vines are rooted in the folklore of cultures from all over the world. For me, however—as a photographer and a dendrophiliac—vines have even greater meaning. They are my secret love. Armed with my Toyo-View 4x5 45CF Field Camera and the remainder of my midsized trust fund, I have traveled the globe to create a spectacular new series of photographs, *Vine Girl: Intimate Encounters with Creeping Plants*, a series of emotive self-portraits in which I am naked, vulnerable, and gracefully entwined with the vines.

From the public parks of Ojai, California, to the jungles of Central Africa, I've had intimate contact with 50 magnificent vine species in 12 countries on five continents. Once I find a specimen that I truly love, I shed my clothes, entwine myself, and direct my assistant to photograph me in blissful, transmutational encounter-ship with the vine. The resulting gorgeous and awe-inspiring photographs address various aspects of the human-vine relationship, reminding us that, amidst the craziness of our modern technological culture and unprecedented climate crisis, we humans are part of Nature.

Alfred P. Sloan Foundation
630 5th Ave #2200
New York, NY 10111

Last year, Golden Gate University neuroscientists recorded brain activity from the visual cortex of subjects who were viewing black-and-white photographs. These images included the works of Man Ray, Salvador Dali, Hans Bellmer, and Claude Cahun. They then used a computational model that enabled them to reconstruct, with surprising accuracy, the photographs that the subject was viewing. This year, their latest experiment went further and actually decoded and reconstructed moving images as viewed by participants. "This is a major step toward reconstructing internal images," said Professor Martha Bernays, a Golden Gate University professor and coauthor of the study published in the journal *Fictional Biology*. "We are opening a window into the movies in our minds."

Using functional magnetic resonance imaging (fMRI) and similar computational models, artist Toby Froud has succeeded in decoding and reconstructing his own visual experiences—namely his dreams. This breakthrough has led to a performance/video art piece called *Morpheus*, which takes place randomly throughout the year at different museums, galleries, and public spaces throughout San Francisco. Tomorrow, Froud is kicking off the piece by sleeping in a second-floor gallery of the Exploratorium: The Museum of Science, Art and Human Perception. He'll be tucked away in a glass box that is connected to brain imaging and computer simulation technology behind a large video screen showing a video relay of his dreams in real time.

Future installations will be more intricate and technically complex. In an undisclosed location, Froud will build an angular tunnel with a custom-built projection screens that will display more live video. The result will be an immersive experience in a synthetic and hypersaturated environment of his mind. He will use projectors and 3-D mapping to totally and perfectly envelop the space with his dream space. This project is sponsored in part by Creative Time and the Alfred P. Sloan foundation.

## Fates and Furries

*Fates and Furries* is a sexually explicit series of video loops created by Naqas Khan and Timothy Houston, a couple of Bronies who met in the Classics and Ancient History (Greek Mythology) Ph.D. program at the University of Birmingham. Their collaboration began when the two staged an elaborate depiction of the Greek myth of Leda and the Swan while dressed as Rarity and Rainbow Dash from the hit cartoon series *My Little Pony: Friendship Is Magic*. While this tableau was made "just for fun," the work received positive feedback both at Birmingham and on DeviantArt.com, inspiring the pair to develop a more comprehensive project.

After years of research, they were able to re-create a complete history of bestiality in ancient Greek mythology though the lens of the *Friendship Is Magic* franchise. Their compelling installation, *Fates and Furries*, is a seven-channel, seven-screen looping film. In this immersive experience, the viewer must piece together and interpret the narrative, which includes a scene depicting Pan and the goat (played by Twilight Sparkle and Applejack) and a scene with Daedalus and the bull (played by Papa Smurf and Scooby-Doo). Viewers are left to determine the cartoon's personal, cultural, and psychosexual significance as they walk through the installation and view all seven scenes.

Lance Jerkins
Professor Robbins
Photography 5212
March 30, 2018

**Final Project Proposal**

Ever since I started school here at RISD, I have been fascinated with textures. This is why I have taken so many pictures of my grandmother's hands. But I am also not afraid to stage a scene or challenge the status quo. Lately I have been tipping over garbage cans on grocery loading docks in order to create cheap, thoughtless, and incredibly self-involved gifts for my girlfriend.

I am not limiting myself to one medium, either; I am also a terrible DJ who tries to make himself seem more interesting by playing cassette tapes at parties in abandoned warehouses before sticker-bombing city buses with my shitty artist school friends. For my final project, I will be exploring the relationship between street art and a total lack of understanding of politics.

## Anarchitecture

Doyle Parker's famed building explosions involve demolishing abandoned structures for the camera. This work stems from Parker's anti-establishment view of the world of architecture and has nothing to do with his lifelong explosion fetish. For his most recent project, *Jerk Off*, Parker packed enough explosives to eliminate the critical vertical structural supports of a suburban home. The placement of the charges and the sequential detonation timing were vitally important, allowing the collapse of the building to be induced by its own weight. This performative act evokes the artist's thoughts on the disintegration of the family unit. His depictions of this explosion are a frenzied visual experience for the viewer and do not double as Parker's masturbatory material.

## Collaborations with the Dead

The dead are a highly elusive audience. However, I am attempting to traverse the veil through my current in-progress project, *Ghost*, which consists of kinetic interactive works designed for postmortem use.

To detect my illusory audience, I have developed a machine, using technology similar to that seen on the hit American television series *Ghost Hunters*, which samples electromagnetic energy and temperature fluctuations. This machine acts as ballast, powering the interactive works available to the ghost(s).

The works themselves are designed from possessions belonging to the recently departed. In order to find these objects, I visit estate sales and funeral homes and subtly ask friends and family which of the dead's personal items were of greatest significance to them in life. Then I purchase or steal these objects. In the end, I construct "smart works" that are continuously searching for the dead and affording them the opportunity to interact with the physical world.

For example, I recently met Molly Jensen, a potter, whose husband, Sam Wheat, a banker, was murdered by a friend and corrupt business partner, Carl Bruner. I have enabled Molly's potter's wheel to be powered by my machine and come to life whenever it senses Sam's powerless spirit. This way, Molly and Sam can connect again. That said, Sam must seek the help of Whoopi Goldberg to protect Molly from Carl and his goons.

## The Biomorphic Wedding

Inspired by Sigmund Freud's writings, the Surrealists believed that what is thought of as reality is actually a projection of the subconscious. My lifelong study of the writings of Freud and their relationship to visual art are evident in my wedding photography. My images of the groom and his best man at the altar, the bride and her dad walking down the aisle, and the bride's father "giving her away" to the groom all reveal latent perverse sexuality, scatology, and relational decay.

Fundamentally, when I observe a wedding, I view it through man's most basic drives: hunger, sexuality, anger, fear, and ecstasy. I find this is most evident in my depictions of the bride and groom feeding each other cake, the bride throwing her bouquet, the garter toss, and the bride and groom leaving the reception in their heavily graffitied car. What formalized displays of Freudian id!

While few contemporary wedding photographers identify as Surrealists, I find this modality valid because exposing uncensored feelings is an important part of many other forms of art. In my formal, staged images, I try to capture the underlying tensions between the bride and her family, the groom and his high school friends, and the couple and their grandparents by offering totally irrational instructions. This serves to make the final wedding album as ambiguous and strange as life.

## About a Steve

My photography addresses the idea of Steve, my mother's boyfriend, who is not my real dad. Ever since I was a preadolescent I have been fascinated by the essential unreality of Steve's endless supply of white crew socks, which I explored through an early photographic series, called *Those Are Stupid Socks and You Can't Tell Me What to Do!* However, what started as a triumph of strategy soon became futility, leaving only a sense of nihilism, leading to my most recent performance, *Listening to Tool Loudly in My Bedroom with the Door Locked.*

# The Anxiety of Photography

It is predicted that the Earth will support more than 8 billion people by 2019, and about 5 billion of those people will have a mobile phone with a built-in camera. If each of those people takes around 10 photos per day, that's more than 15 trillion photos annually. These images are a type of digital pollution, both figurative and literal. Once shared on social media platforms, these images are housed in data centers. Thousands of data centers, spread over hundreds of thousands of square feet with banks of generators and industrial cooling systems that emit toxic diesel exhaust— all so that millions of idiots can take the exact same photograph of their family crossing Abbey Road.

For this reason, I work exclusively with existing images, found on social media sites like Instagram, Imgur, Flickr, Photobucket, and Shutterfly. I began the project *Vacation Photographs* from Instagram in 2012. Looking for the most photographed subject, I searched the photo-sharing platform under #travel and found 3,655,041 images. I collected the most ubiquitous subjects—the person posing as the Statue of Liberty next to the Statue of Liberty, the family making faces at a member of the Royal Guard, the divorcee meditating at the Taj Mahal, or the man using forced perspective to make it look like he is squishing the Washington Monument. I then printed photographic murals made of thousands of images. To my dismay, I found that viewers most often responded to my work by using it as a background for their selfies, which they posted on social media.

## Mini Dome with Surveillance Camera 5347

Mini Dome with Surveillance Camera 5347 is a surveillance camera that lives and works in the south corridor on the 5th floor of 526 West 26th St. in New York City. Mini Dome with Surveillance Camera 5347 creates long, uninterrupted shots of a hallway, where there is little movement. These films, which have been referred to as "durational photographs," are a meditation on the present moment. Mini Dome with Surveillance Camera 5347's work is presented alongside other Mini Domes with Surveillance Cameras' footage from other corridors within the building. This multi-channel installation is broadcast in real time on screens in the building's security office, and on occasion, at the Dia Beacon.

# BORGES!

**Dear Sea Breeze Condominium Residents,**

Last summer I was hired as a seasonal housecleaner by Castillo's Cleaning and Gardening Services and was assigned 12 homes in the Sea Breeze Condominium Complex to clean each week, including yours. This position allowed me to earn the money necessary to complete my education while I worked on my Oberlin College undergraduate thesis project, *What's in Your Drawers*. By using an ever-growing archive of images of objects found in your home, I have created autonomous artworks.

These artworks document my time in each of your 12 homes in both images and text. My photographic images catalog the objects found in each of your top drawers. These images include pictures of intimate objects such as undergarments, a rusty old knife, and $51,080, mostly in $100 notes. The accompanying text includes an itinerary of my activities in your home, such as reading your diaries and experimenting with your prescription medication. I am pleased to report that the exhibition presenting this work was a great success. Please enjoy the attached images documenting the opening.

Warm best,
"The Girl"

## Lump of Plastic

This is my plastic toy.

Leave me alone and let me play!

I am a plastic kid.

I let the child inside run riot.

I'm not thinking at all.

I tinker and poke without any worry.

Light leaks, vignetting, multiple exposures.

It's light, sturdy, covered in electrical tape.

I do not care if it breaks.

I got it at Urban Outfitters for $30.

## Caleb Lewis: Family Portrait Photographer

Caleb Lewis (b. 1988, Atlanta, Georgia) has a BFA from the Ringling College of Art & Design and Master of Arts in Photography from Savannah College of Art and Design and is lucky enough to be one of Walt Disney World's Magic Kingdom park photographers. As a Disney portrait photographer, Lewis is hired by guests to take pictures of them enjoying the park's prime attractions. Lewis knows from reading and discussing Roland Barthes' seminal work *Camera Lucida* ad nauseam that "not only is the Photograph never, in essence, a memory, but it actually blocks memory, quickly becomes a counter-memory." Lewis takes the responsibility of constructing your memories seriously.

If you schedule a Family Portrait Session with him, he will follow you and your family around on your vacation, quietly exploring the relationship between photography, memory, and death from a discreet distance. While photographing you, Lewis will focus on what Roland Barthes called "the studium," the vague details which constitute a photograph's subject and context—in this case, you and your family. Lewis hopes that many years later, when you see these images, you will experience something highly subjective and even sentimental: what Barthes called "the punctum." When he is not shooting, Lewis lives in a secret studio space under Splash Mountain.

## Derk Johnson: Artist Statement

I use my camera to blend my formal training in visual art with my total lack of understanding of basic high school science in order to create abstract images. I do this by haphazardly experimenting with the basic elements of optics and calling my failures discoveries. This allows me to reference the advent of photography, when the medium had no set standards and was intrinsically linked to science.

My studio is lined with scientific textbooks. I am talking about the real dense technical stuff. I don't understand a word of any of it. I have a BFA, an MFA, and a PhD, but I've never actually taken a single science class. However, when curators, dealers, and collectors visit, I get to point to my dusty books and say things like, "Our eye doesn't see like a camera, yet there is this belief that photography is equivalent to our experience of reality." This effectively validates my works.

Furthermore, I've gleaned from *Watch Mr. Wizard* that we lack the sensory mechanisms to see real colors with our naked eyes, and I use this as a metaphor for our inability to see the extent of the physical universe, whether it includes multiple dimensions or parallel universes, two things I have totally heard of.

**You Are the Wind**

Here are nine close-up portraits of a pale-faced young woman shot in the wind. These pictures are displayed and must be viewed in order. This is because the first portrait shows a strong wind blowing the woman's hair to the right, the second portrait shows a slightly weaker wind blowing her hair to the right, the third portrait shows a weaker wind blowing her hair to the right, the fourth portrait shows an even weaker wind barely blowing her hair to the right, the fifth portrait shows the subject with no wind blowing, her hair falling limply down her shoulders, the six portrait shows a new wind blowing the subject's hair just slightly to the left, the seventh portrait shows a stronger wind blowing the subject's hair to the left, the eighth portrait shows an even stronger wind blowing the subject's hair to the left, and the ninth portrait shows her dressed as a northern hawk owl, a non-migratory owl that usually stays within its breeding range, though it sometimes irrupts southward. However, the woman herself is not the subject.

## The Life-Changing Magic of Photo-Based Formalist Sculpture

While photography is the foundation of her practice, Daria Reese's pieces each incorporate aspects of sculpture, collage, and the concepts from Marie Kondo's self-help book, *The Life-Changing Magic of Tidying Up: The Japanese Art of Decluttering and Organizing*. Reese's recent pieces incorporate sections from hundreds of images from previous photographic works, all of which the artist hoarded in her studio before discovering the decluttering guru's seminal text. After reading Kondo's little turquoise book, Reese learned to put her hands on every print in her flat files, ask herself if it sparked joy, and if it didn't, thank it for its service and rip it up. Second, she learned to put every scrap in a place where it would be visible. She did this by arranging the scraps into three-dimensional compositions—generally formal still lifes—and then photographing and printing these works. The results of this painstaking process are vivid, ecstatic, and ultimately take up even more space.

## Koko

Koko (b. July 4, 1971) is a female western lowland gorilla who primarily works with paint. She has produced hundreds of acrylic paintings on canvas by painting rapidly and spontaneously, finishing paintings in minutes, rather than hours or days like many human artists. She is not often self-conscious about her process, although she once signed a piece she did not like "toilet."

While her paintings range from the highly literal to highly abstract, Koko creates minimal art with a clarity of content, which is never aloof or systematic. Her painting *Bird* was based on a fledgling Steller's jay named Tongue, who for a time would come visit the artist in her cage. In contrast, her ironically titled work *Love*, a bright pink and orange abstract piece, was the result of her captors asking her to paint emotions. With an earnest and minimalistic approach, she makes intensely personal paintings, which incite us as viewers to make new personal associations of our own.

For a complete catalogue raisonné, see the Gorilla Art section of KokoMart (the Gorilla Foundation's online store).

**FOR IMMEDIATE RELEASE**

## Bestowal Gallery presents Natalie Davin's new work, *Second Generation*

Bestowal Gallery is pleased to present *Second Generation*, a solo exhibition featuring works by Natalie Davin. This will be the artist's seventh exhibition with the gallery in the past seven years. *Second Generation* borrows its name from *The Picture Generation*, which was the name of a landmark exhibition at the Metropolitan Museum of Art in New York, as well as the name of the group of appropriation artists from the 1970s and 1980s it featured. By exhibiting existing images from advertisements and news media after making few to no changes, this group of artists explored how images shape our perceptions of ourselves and the world, while they saved the time and resources it would have taken to make their own images.

Similarly, Davin has things to do. She has emails to return and laundry to wash, and she definitely needs to walk Sandy more—dogs should spend between 30 minutes and two hours outside every day. So *Second Generation* just features mural-size prints of profile pictures from Tinder.

Conceptually, this artistic gesture echoes those of image-scavenging artists like Louise Lawler and Sherrie Levine, who occupied the space between the "original" and the "copy" to challenge the distance between objective document and subjective desire and to free up time for weekend trips upstate. Davin's previous work, which referenced *Picture Generation* artists like Cindy Sherman and Laurie Simmons, who worked at the intersection of personal and collective memory, was a lot of work to make. *Second Generation* took much less fuss and freed up time for her to finally learn German. Well, take German. OK, sign up for a German class.

While Davin's influences did work with a sea of images from the media culture of movies and television, popular music, and magazines, they could not have predicted the coming of social media, a mechanism of seduction and desire like no other. This never-before-seen, highly refined means of social construction is a wellspring of content for Davin, who spent hours collecting material on Tinder. Plus, Tinder and art—two birds, one stone, right?

## Streetwise

My great-uncle was an Italian street photographer who immigrated to New York City in the 1930s. His work comprised unmediated chance-encounter portraits within public places. Growing up in a house with him, I've developed an acute sensibility for capturing candid photographs. I understand that behind every great street photograph, there is a brilliant photographer bothering a pedestrian.

Early in my career, I saw an older gentleman who had fallen outside the coffee shop below my apartment. It was such an authentic moment. You could taste his humiliation. I ran upstairs to retrieve my camera. However, by the time I returned, I barely had a chance to make my subject feel deeply self-conscious before he got up and left me with no usable shots. I knew I would never make that mistake again.

Now I carry my camera everywhere. It is an extension of my body. I never know when I will catch a glimpse of some pedestrian on the way to work and feel that sudden urge to capture them without their permission as they try to avoid my gaze. There's nothing better than coming across an interesting and easily unnerved subject trapped on the express train with me. I love to stare at them through my viewfinder from three or four feet away, just waiting for what Henri Cartier-Bresson called "the decisive moment." I love switching seats to get a better angle on a commuter who has unfolded a newspaper in an effort to block my view. I love photography.

## Amy Litzy

Amy Litzy uses photography to examine people of affluence and their cultural influence. She has traveled the world—from Bel Air to Dubai—documenting the 1 percent. Her work critiques the globalization of materialism. Though her images are filled with aristocrats and celebrities dressed in high-end fashion, they are shot without desire or reverence. This sometimes biting social critique of the wealthy can be seen anywhere, from the walls of Chelsea galleries—where parking costs $15 every half-hour—to the homes of billionaire trophy wives, where it offsets the well-appointed furniture in great rooms.

"In retrospect, Litzy's been documenting the rise of the 1% for decades," states Elaine Chandler in the introduction to Litzy's recent monograph, *$175 Coffee Table Book*. This luxury good acts as a cold mirror, plaintively asking the shapers of society to consider what they've done to the American Dream while acting as an object of interest whose unusual quality makes it a great ice-breaker for dinner guests.

Those viewers who have financial or even cultural access to Litzy's work can see her sharp critique of the widening gap between the rich and the poor, between what we desire and what we can afford. Like, for example, her photographic prints, which sell for about $10,000 each. You can't afford that? Or can you? Please contact Caroline Jordan Fine Art for more information.

# I Want You to See Me Naked

By appearing poised on my dorm-room bed wearing Frederick's of Holly-wood Halloween costumes and no make-up, I use my young, attractive form to interrogate self-objectification. I explore the tension between female sexuality and capitalism with my smoking-hot body, by showing my perfect, glitter-covered breasts in each frame.

I employ the performative dimension of language in these images by hand-writing text across each print. This text is from pornographic conversations I have had online, under a pseudonym, with my father's friends, colleagues, and boss. This text addresses the ongoing interplay between identity and temporal/spatial dynamics and "where I'm going to put it if you're good."

I am intrigued by the dialogue between the subject-object relationship. I seek to rupture my continually deferred relationships with accountability and healthy boundaries in the liminal space between post-feminism and self-harm. Ultimately, these sexy images problematize the traditional relationship between the female fetish object and her spectators: Thursday morning's Photography 201 students and our awkward, stuttering, Humbert Humbert-esque professor.

**Chad Powers**

Chad Powers (b. 1997, Saddle River, New Jersey) is a photographer who works with a Mamiya 7 and 6 x 7 color film. He considers photography a craft conforming to clear formal rules and structures. This is evident in his early series *Authentic Pictures of Amy*. Each photograph of the artist's now-former girlfriend is meticulously composed within the golden ratio, including candid photographs of her weeping in their shared bathroom after her mother's funeral.

By focusing on composition and materials, Chad is able to avoid addressing contemporary social issues as well as the legacy of art history. It could be said that Chad, presently traveling across country by skateboard, is capturing a contemporary version of America in the tradition of Stephen Shore, Robert Frank, and Walker Evans, but Chad has never heard of those people. When he is not skateboarding across the United States, Chad Powers lives and works in Brooklyn, N.Y., in a neighborhood his realtor assured him is "basically Williamsburg."

## *How to Live Forever*: A Series of Enigmatic Portraits

There are two certainties in life: you are born and you die. In contemporary Western culture, we want to live as long as possible and think as little as we can about death. My photographic series *How to Live Forever* confronts our fears head-on.

The project is inspired by Egyptian mummy portraits and Victorian death photography. The Egyptian mummy portraits from the Fayum Valley (100 BC to 300 AD) are the oldest images of persons that have been found to date. Artists created these portraits to show how their fellow Egyptians wanted to be remembered after death. The portraits hung in the Egyptians' homes and after death were wrapped in the linens of their mummified bodies. In Victorian England, death photographs, or *memento mori*—literally meaning "remember you must die"—were photographs taken of the recently deceased. These photographs of deceased loved ones were a normal part of American and European life and were a way of commemorating the dead.

My project combines these two histories to confront death head-on. For each piece, I murdered one subject. Then I inserted a hook through a hole near the nose of my subject and pulled out their brain. Next, I made a cut on the left side of the body near the tummy to remove all of the internal organs, let the internal organs dry, and placed them inside canopic jars. I placed my subjects in sarcophagi and buried them in the earth. I later excavated them, unwrapped them, and took their portraits in tintypes or ambrotypes. This gives the subject a rosy tint. I used a 19th-century metal stand and other devices to pose the dead as though they were living. The photographs were then themselves mummified and buried in the earth, then unearthed and dried and molded in resin. My subjects are dead, yet immortal.

## Art Photography by Eric Darbinyan

*It is the spectator, and not life, that art really mirrors.*
—Oscar Wilde

I use mirrors, windows, waterways, and other reflective surfaces to transform my otherwise straightforward images into more "artistic" works. Wine glasses are a recurring theme in my work. By placing a half-full (I'm a half-full kind of guy) wine glass in my shot, I can flip the landscape or cityscape behind it upside down. This juxtaposition gives my images a real "arty" look.

These images lend themselves best to gallery-wrapped inkjet printing on canvas, stretched over stretcher bars so that the sides will be a continuation of the image. This gives my images a "painted" effect, which is more artistic. Plus, it allows my customers to hang my work in humid areas of their homes or offices, such as the bathroom.

**Ryan Ward's Artist Statement**

My name is Ryan Ward, and I have spent the better part of my life taking photographs of bridges. I think the thing I love best about photographing bridges is that it provides me with a good distraction from my life while requiring very little of me as a person. It's like watching *Law & Order*. There's no wrong way to photograph a bridge. You can focus on the whole bridge or just one part of the bridge. Either way, you are not focusing on your own crippling sense of emptiness.

All photographs of bridges look great! This is because bridges are the work of talented architects who have done most of the work for you. All you need to do is work the shot, which just means trying out different positions in order to get different compositions. For example, when I photographed the Brooklyn Bridge on a trip to visit my sister, I shot the historic landmark from below. I knew I had chosen the right spot because of how many other photographers I saw shooting selfies from this vantage point. I had postcards made and everyone loved them. I guess I could have bought postcards of the Brooklyn Bridge, but then what would I do to distract myself from the monster lurking deep inside me?

Bridges don't just provide me with readymade images; they also come with their own built-in meaning. A bridge is a metaphor for just about every-thing. They are metaphors for human connection, life's journey, and even civilization itself. As Werner Herzog says, "Civilization is like a thin layer of ice upon a deep ocean of chaos and darkness."

**Transcript from "The Bare Collective Panel" at Eyebeam on
July 31, 2017**

Speaker: Hello and thank you for coming out. We are Bare, a collective
of female and/or gender-queer artists who examine self-representation
on the Inter—... excuse me, sir, could you please put your hand down?
We'll be doing a Q&A at the end. Where was I? Right! Throughout the
history of visual art, the naked feminine body has been a central subject in
male-authored works of art. Frequently, the woman's silent form is mined
while their voice is... really, sir, could you please put your hand down?
It's not your turn to speak... In hopes of reshaping preexisting narratives
of gendered appropriation, artists today use the Internet as a platform to
respond... Fine. What?! What the fuck do you need to say so badly, dude?!

## Aaron Richards

Aaron Richards (American, b. 1984, San Diego, California, based in Los Angeles, California) is known for using a multidisciplinary approach to art-making, incorporating photography, sound, sculpture, and nature itself in his large-scale installations. His works explore the intersection of light, space, and time, as well as his bottomless need for approval. Despite his interdisciplinary approach, his aesthetic is informed by key intellectuals of the Minimalist group. He cites Donald Judd, Sol LeWitt, and Dan Flavin as major influences and is terrified to admit there is anything about art or life that he does not already know.

Like a Rube Goldberg machine, Richards includes a chance element in each installation. This element of chance can be anything from the unpredictability of viewer engagement to the weather to swarms of live bees, and is most often chosen in response to the installation site itself. By incorporating chance, his art reflects life's physical circumstances, rather than denying them. Richards explains: "My installations are not only investigating space and time as art forms but also, you like me, right?"

Richards wants his works to exist together in three-dimensional spaces and in relation to each other, rather than representing a fictive space, as with traditional art. He incorporates found materials in his installations, like stock sounds of bird calls, reducing the visible hand of the artist and allowing the viewer to have their own experience and really love him for it.

## The War Against Reality

*Imagination is the only weapon in the war against reality.*
—Lewis Carroll, *Alice in Wonderland*

My fairy-tale images are like spells cast in an attempt to build an alternate reality. Through staged photography, I visualize the fairy tales of my childhood, such as Lewis Carroll's *Alice's Adventures in Wonderland*; its sequel, *Through the Looking-Glass*, which includes the poems "Jabberwocky" and "The Hunting of the Snark"; and J. M. Barrie's *Peter Pan*.

In my series *Wonderland*, I depict such scenes as Alice falling down the rabbit hole, Alice playing chess with the Red Queen, and three cards painting the roses red. These fantastic images are a means of creating a new world in which the illusions of these stories are truth. Like Alice, I've made it to the other side of the mirror. Here Alice is an imaginative, precocious young lady, not the reluctant muse of Lewis Carroll, a heavily repressed pedophile.

I think we can all relate to my imagining of Alice in one way or another. It may be her imagination, her curiosity, or maybe it is our collective memory of hearing the fairy tale during childhood, long before we saw that creepy photo of the author kissing Alice Liddell in 1852, when the child was seven.

I shot these portraits of my Alice through a 100-year-old antique lens, akin to one that Carroll may have used to shoot countless photos of Liddell throughout the course of her life. This glass gives the dreamy look and adds a splash of magical. My tea party props and Photoshopped floating Cheshire Cat create a fanciful world absent of any of the overwhelming evidence of Carroll's unhealthy obsession with minors. I think we all wish we could go down the rabbit hole at some point in our lives.

Similarly, my series *Neverland* is definitely not about how J. M. Barrie manipulated his way into the lives of the Llewelyn Davieses, parents of Peter, on whom he based his book. Nor does it depict an adult Peter Llewelyn Davies throwing himself in front of a train after destroying all the letters from Barrie to him and his brothers, saying they were simply "too much." That would not be whimsical at all. My fairy-tale tableaux instead heavily feature Renaissance fair costumes and Halloween store props and transport you to a world of wonder, heavily limited wonder.

## *Belongings*

*Belongings* is a new site-specific installation of photographic images that I printed on Xerox paper and wheat-pasted directly to the walls of Brooklyn Art Space's room #407, where I currently share a studio with 17 other lens-based media artists. Using objects scavenged from my studio-mates' work areas and our shared garbage can, I composed impromptu still lifes for the camera. These assemblages do not follow any logical criteria and are based only on subjective associations and formal parallels. I hope this will invite the viewers to ask more pressing questions than just, "Hey, how did you get into my locker?" Instead, I hope this installation challenges the binaries that we continually reconstruct between self and other.

## American Sheeple

In *The Matrix*, Neo has a hollowed-out book where he hides things. The book is titled *Simulacra and Simulation*. This text by French philosopher Jean Baudrillard is the basis for my final project, *American Sheeple*. The philosophy of Baudrillard as discussed in *Simulation and Simulacra* is revealed in *The Matrix*, when Morpheus speaks of the "desert of the real." He is basically paraphrasing the first chapter of *Simulation and Simulacra*, which is the chapter I read. In it I learned that the world is no longer really "real" and instead it has become "hyperreal," a simulation of reality that is disconnected from whatever was real before, like Disney World... or photography.

My images, ironically photographs themselves, explore the notion of Disney World as a dystopian paradise. In it I picture tourists in their too-perfect repressed paradise in an effort to hold the mirror up to society and show people that their reality is really a simulacrum, like Morpheus did for Neo, or Baudrillard did for my Philosophy 101 class. At first I didn't even want to go to Disney World with my stupid parents and annoying sister, but then I realized that I could use the trip to make work about "the American dream" and the nature of reality and *The Matrix* and French philosophy.

## L. B. "Jeff" Jefferies's *Rear Window*

L. B. "Jeff" Jefferies (b. 1954, New York) is a professional photographer of some sort who lives in Greenwich Village. His photos feature coincidental, accidental, and unexpected connections. For his series *Rear Window*, he used the restriction of a broken leg to create work from the confines of his Greenwich Village apartment, which looks out onto his apartment complex's courtyard and several other apartments. From this vantage point, he made the private into the public by observing his neighbors through his camera's telephoto lens. By experimenting with this aleatoric process, Jefferies formalized the coincidental nature of the seemingly random acts of these neighbors. This unfiltered work is intentionally highly subjective, which is underscored by his captions "Miss Torso," "Miss Lonelyhearts," and "Lars Thorwald Murdering His Bedridden Wife."

**Nlag Gallery**
DaleLan Art Center
2735 Main Street
Baltimore, MD

**FOR IMMEDIATE RELEASE**

**Jayden Cockram's *Empty Room***

Jayden Cockram (American, b. 1971, Washington, D.C., based in Baltimore, MD) mourns the death of analog technology, not by focusing on the dematerialization of the image as a physical art object, but instead by investigating the chemical compounds of classic darkroom photography. To this end, Cockram has released vaporized chemicals throughout a gallery. At first glance, the viewer may imagine he or she is in an empty gallery, surrounded only by white walls. However, the careful observer will gradually notice headache, nausea, confusion, weakness, fatigue, loss of coordination, hyperventilation, and, eventually, loss of consciousness.

# Holtie

Sculptor Thornton "Holtie" Rose Woodard died, tastefully and discreetly, at the age of 87, in Newport, Rhode Island, on July 8, 2017. Holtie was linked to the famed Genetic Entitlement group, which redefined the mediums of photography, painting, and sculpture in postwar Connecticut. He is best known for his unique welded works from the 1950s, which depicted comically large piles of mashed potatoes in bronze. Woodard said that his works somehow revealed the closed-door behavior of people who publicly have a deep, instinctive sense of manners and propriety.

Woodard is survived by his wife, Bitsy, a horsey girl from Connecticut who, while pretty, is not into showing off; his daughter, Elizabeth "Izzy" Woodard-Rapapologist, of San Francisco, California; and his son, Chase Underhill Woodard, of Portland, Oregon.

Holtie was an accomplished conversationalist with a willingness to entertain and discuss others' views and beliefs, at least until he acquired sufficient understanding of them to be able to silently conclude that they were erroneous. He also was a generous individual who loved donating his metal works to charities and had a deeply condescending kindness toward those who were less fortunate.

A funeral reception is scheduled for later today at Holtie's son-in-law's summer home in Princeton, New Jersey. Pastor Pippin will officiate the ceremony. Dress is casual; please do not try too hard: old khakis, worn loafers, a frayed button-down shirt, and a tweed jacket going out at one elbow would work well. All who are able to find our estate, which is unavailable on Google maps, are welcome to attend and celebrate Holtie's life. In lieu of flowers, please send donations of money—things aren't going as well as they seem.

## Wanderlust

I use 19th-century photographic technology in conjunction with the chance elements of nature in order to explore our relationships to landscape, time, and the ephemeral. My work consists of camera-less Kallitypes and Vandyke brown prints made in collaboration with the elements. The elements that I typically employ in this process include the sun, ocean waves, and rain water. These create abstract images through direct contact with my hand-coated, light-sensitive papers. The results look brownish and boglike. This is no matter, as I am focused on process, impermanence, and the sublime and have no formal concerns.

I am inspired by some things Rebecca Solnit wrote—not the feminist stuff but the Romantic stuff about walking and the vastness and the strange nature of time. My pieces are never fully photochemically processed and continue to fade over time in response to the light in their environments, muddying the line between creation and destruction. However, I selectively re-photograph moments in the devolution of my images, so you'll have something to purchase at Yossi Milo Gallery. Otherwise, by the time you hang one of these guys in your fancy-pants living room, it will pretty much look like framed sheets of yellow paper.

### *How Did Those Girls Get There?*

*How Did Those Girls Get There?* is an exhibition by Egorygray Ewdsoncray that includes large-scale tableau photographs of remote neo-romantic landscapes inhabited by young adolescent women, naked and seemingly unaware of each other. Her works invite a contradictory familiarity and distance from her viewers by offering a reality where dystopia and utopia are not opposites, but rather commingled into half-dreamscapes. Because these photographs are unresolved, viewers bring their own stories and answer their own questions—questions such as: Wait, how did those girls get there? Is there some bus that takes nude teenage girls to remote landscapes? Did they come together? If so, why are they all staring off in different directions?

## Dexter Morgan

Dexter Morgan (b. Miami, Florida, 1971) is a crime scene photographer, blood spatter analyst, and serial killer. His day job allows him to provide the Miami-Dade Police Department with forensic records and analysis of crime scenes. He then doctors those records in order to stalk and ritualistically kill the suspects himself, and contributes to the canon of crime photography, which began with the work of Alphonse Bertillon, who photographed murder victims in France at the turn of the century and who was, ironically, also a never-apprehended serial killer with a heart of gold.

## *What Does My Gut Say?*

*Cogito, ergo sum.* Modern Western philosophy is founded on these words. When René Descartes famously came to the conclusion "I think, therefore I am" more than 350 years ago, he thought it undeniable.

At a distance, his argument seems sound. If I can think critically about the certainty of my existence, I must be able to think, and if I am thinking, then I must exist. But there is a crucial question that Descartes overlooked: Who is this "I"? Is it my brain? My mind? My soul? Am I an autonomous thinker, or the sum of my experiences? What does my gut say?

In our literal guts, hundreds of millions of neurons connect to our brain. This is called the brain-gut axis. Recent evidence indicates that our microbiota, the bacteria that live in our intestines, are playing a much larger role in influencing our brain and behavior than most anticipate. Can we be influenced by our guts to fall in love, to become a killer? Certainly, our conventional idea of continuous identity is flawed, or at the very least outdated.

I've teamed up with my own microbiota to create a series of oil paintings titled, *What Does My Gut Say?* Each painting was conceived and executed on a different diet, designed by a nutritionist specializing in microbiota health. For example, I painted the triptych *Yoga Dress Pants* while on a monthlong Paleo Diet and the double-sided painting *View from My Hospital Bed* while on the Tapeworm Diet. These paintings challenge the coherent conception of what it means to be a human being. They raise difficult questions of moral responsibility and free will that arise from a microbiological vision of identity.

**Outline for My Future Biography:**

1. Graduated from mid-level art school with BFA.
2. Moved to Lower East Side with friends.
3. Worked in major artist's studio as assistant and at a Chelsea gallery at
4. the desk.
5. Had a local solo show in Midwest hometown.
6. Produced posters for local sales.
7. Held a related workshop.
8. Entered and won a juried exhibition.
9. Featured in quirky art magazines.
10. Had a show in a more important gallery.
11. Quit gallery job.
12. Increased prices. Attended festivals.
13. Quit studio job.
14. Signed with more important gallery.
15. Solo shows in Europe.
16. Increased prices.
17. Created a catalog.

18. Featured in better magazines.

19. Licensed images for other products.

20. Residency.

21. Regional museum exhibition.

22. Married.

23. Raised prices.

24. Baby.

25. Visiting faculty.

26. Baby.

27. Assistant professor.

28. Mortgage.

29. Associate professor.

30. Baby.

31. Major museum exhibition.

32. Raised prices.

33. Died in a freak accident (picnic, lightning).

## Photographing Clear

*I won't take a photograph of anybody or photographs for anybody*
*unless I feel it will do them some good.*
—L. Ron Hubbard

As a photographer, I love to go to the shore near my home in Clearwater, Florida, and shoot macro images of the clams. Human beings evolved from clams. Yes, clams. Yes, we did. I also love shooting candid portraits of humans. However, I always avoid shooting pictures of the "thetans" who live among us disguised as humans. Yes, there are aliens who live among us disguised as humans. I can tell who they are, and I don't take their picture. Most of all, I love traveling to New York once a month to take surveillance pictures of Suri Cruise.

## Samuel Lee

Samuel Lee (b. 1965, Chicago, Illinois) is a police officer with the Chicago Police Department (CPD) who uses a body camera to chronicle his workdays. Lee intentionally neglects his equipment in order to produce painterly imagery, reminiscent of the Pictorialists, and even at times alludes to the work of painters like Gerhard Richter and J.M.W. Turner. The artist is largely concerned with the breakdown of representation, when it comes to depictions of chokehold, nightstick, and other sorts of police brutality. Lee is represented by the Chicago Police Department, and his work is available nowhere; they accidentally taped over it and there are no copies.

## *Scopaesthesia*

*Scopaesthesia* was a performance piece that I staged every day between August 1 and October 31, 2016—weather permitting—on the streets of Brooklyn. For this piece, I followed my ex-girlfriend around the city, from when she left her apartment until she entered another indoor space, such as a bakery or the New York City Police Department's 83rd Precinct. These performances ranged in length from one minute (when she got into an Uber and I couldn't hail a taxi quickly enough to keep up with her) to four hours (when she ran the New York Marathon).

This group of performances explored the relationships between men and women and the complex codes that structure the way we behave. It was inspired by the paradigm shift that took place in the art world during the late 1960s, which brought art out of the gallery and into the street, as well as by my desire to know where Lisa was at all times. A photographer documented each performance piece, and these images are included in my forthcoming artist book, *The Bad Boundaries of Bushwick*, which is printed in Risograph and published by Sun Press.

### *I Bought a Drone!*

I am most drawn to desolate or barren landscapes. My recent series of images, aptly titled *I Bought a Drone!* explores man's impact on our natural... I have a drone! By seeking out dramatic visual evidence of man's impact on his environment, I totally get to fly my drone. My work can be best viewed in the YouTube compilation "Drone Fail Crash Compilation 2017." I am currently working on a new series of images called *I Bought a New Drone!*

## Small People

Mary Ellen Mark once said, "I've always felt that children are not 'children,' they're small people. I look at them as little people and I either like them or I don't like them." I'm hoping you "like" my small people, or at least my photographs of them, in my new Instagram series, *Never-ending Family Slideshow from Hell*. By oversharing every moment in my small people's lives, I am examining the role of juvenile bodily autonomy in our culture. Children's-rights advocates believe that small people should have a voice in what information is shared about them. I believe I need the regular spikes in the pleasure centers of my brain that studies show result from obsessive posting.

The more likes I get, the better I feel. And what gets the most likes? Photographs of children... I mean, photographs of small people. My images of small people don't just provide me with the attention I so desperately need; they also open up a dialogue about our addiction-addled culture of overshares. Just look at all the nasty comments in my thread.

My images are good for my small people as well. By posting photos of my son while he is bathing or my daughter on the potty, I am creating bullying fodder that will someday make my future large people stronger. Most small people will never experience problems related to what their parents share, but a tension still exists between my right to share my small people's every waking (and sleeping) moments and their right not to end up on an online child pornography site. Like it or not, this fertile territory is ripe for exploration. But seriously, like it. I need this.

## Light

In my photography, subject and content are one and the same. My work is first and foremost about light. I image dark backgrounds with empty foregrounds bathed in bright white lines of light or a beam of light streaming through a window, just outside of view. I shoot to capture the abstract forms offering themselves through such openings. Light illuminates everything that I see, yet in its totality it is mysterious, evasive, the elusive Daphne running from Apollo. The ostensible purity of white light cloaks brilliantly the invisible spectrum of colors, as Newton discovered when as a schoolyard chap he plunged a needle into his own eye. In contrast, darkness—light's brutal twin—is the temptress Marlene Dietrich as Amy Jolly, in a tux, performing "Give Me the Man" *en français*. Light and darkness are separated by a thin veil, like life and death, like men and women; coruscation reigns. I do shoot, I shoot, and shoot, but light and darkness are my true medium.

**Steven Bridge: Google Street Car artist**

Lev Manovich wrote, "The reason we think that computer graphics technology has succeeded in faking reality is that we, over the course of the last hundred and fifty years, have come to accept the image of photography and film as reality."

Steven Bridge is interested in the ongoing relationship between technology and perception. As a Google Street Car Driver, Bridge mines the creative possibilities situated at the intersection of photography, cinema, architecture, and technology: particularly databases and algorithms. This cross-media digital art project is funded by Google and exhibited via Google Maps Street View.

Bridge is able to avoid the gallery system altogether and connect directly to his viewers because Street View is available as a component of Google Maps, which exists as a Web application and as a mobile application for Android and iOS. Bridge is also able to subvert the antiquated notion of authorship because Google Street View anonymizes his and his fellow artists' work.

The Google-issued camera atop his private car provides panoramic views from positions along the streets he drives, which Google Street View displays as stitched images. This means his photographic process connects one image to the next and the next and the next, instead of isolating each work and giving it its own precious, special meaning.

### *Photography of Magic*

*Photography of Magic* is a large-scale photo essay that depicts the practices of magicians and illusionists, all of whom are concerned with the relationship between magic and material presence. Magicians like Jerry Sadowitz, best known for his foul language, and Penn and Teller, noted for combining comedy with magic, examine the scope of magical possibilities at play within the contemporary cultural landscape, while David Blaine, best known for his high-profile feats of endurance, and Criss Angel, known for his mind-bending live performances, reframe magic for the post-Internet age. *Photography of Magic* is for budding magicians interested in gaining a better sense of contemporary magic by looking at photographs.

## How to Get High in the Woods

I believe that if well planned, getting stoned in the woods lends itself to enjoyable art marking. As a professor at the Evergreen State College, I have access to 1,000 acres of old-growth forest. I am not suggesting that I make better work by getting baked. In fact, on my most recent excursion, I think I forgot to take the lens cap off my parallax Fuji 6x9 for all but one frame. However, I am telling you that I enjoy making art most when I am high in the woods. I am saying that weed + film + forest = magic.

This summer I discovered Blue Mystic. It is as mysterious as its name indicates, with unknown genetics that definitely includes some Blueberry and possibly some Skunk or Northern Lights. It flowers for seven to nine weeks, with a light blue coloring. I really enjoyed just looking at it. It is a beautiful object. I enjoy smoking it even more. Blue Mystic also has a subtle blueberry aroma, making it a good choice for growers—or college professors, who are technically not allowed to be getting high on campus—who need a little discretion.

I can't tell you much about my Blue Mystic hike itself. I think I saw a dog at some point. I know I shot one roll of film. At no point did I think about the art world or wonder what I was doing with my life.

A medium-format roll of film gives a photographer four frames when shot at a 6x9 aspect ratio. Of my four shots, one photo came out. I hope you enjoy looking at it as much as I enjoyed taking it. And I hope you don't let art-making stress you out

*Many thanks to Christina Labey,
Marvin Heiferman, Nayland
Blake, and Matthew Carson for
being so generous with your time
and expertise.*

# BIOGRAPHIES

## Liz Sales

Liz Sales is an artist, in the sense that "artist" may be defined as someone who engages in the making of art, regardless of its quality of craftsmanship or depth of content. She has a BA from the Evergreen State College (with a focus on getting high in the woods) and an MFA from Bard College (where Becker and Fagen of Steely Dan met). Sales works as an itinerant adjunct professor, teaching concurrently at the City University of New York, the University of Connecticut, and the International Center of Photography (her second home, as well as Google's second search result for "I.C.P." after Insane Clown Posse). In an effort to possess as many faculty IDs and skeleton keys as possible, Sales also spends her summers teaching at the Evergreen State College and still knows how to find the woods. Sales has written for photo-based art magazines, such as *Conveyor* and *Foam Magazine*, which has given her the opportunity to get to know some of her favorite artists, in the sense that "artist" may be defined as someone who makes art with quality of craftsmanship and depth of content. In her "spare time," Sales also has what the kids call a "side hustle": she writes other artists' artist statements. These are not they.

## Matthew Carson

Matthew Carson is the head librarian and archivist at the International Center of Photography in New York. He is a cofounder of the 10×10 photo-book organization. In 2013, he was a curator of the artist book component of "A Different Kind of Order: The ICP Triennial." In 2015, he was one of the organizers of "Shashin," a Japanese photography symposium and festival held in New York. He is a photography enthusiast, writer, and bibliomaniac. In 2017, he edited and published the catalog for "CLAP! Contemporary Latin American Photobooks." He is a photography enthusiast, writer, and bibliomaniac, and here to provide some much-needed credibility to this project.